Drawing Pets

SALLY MICHEL

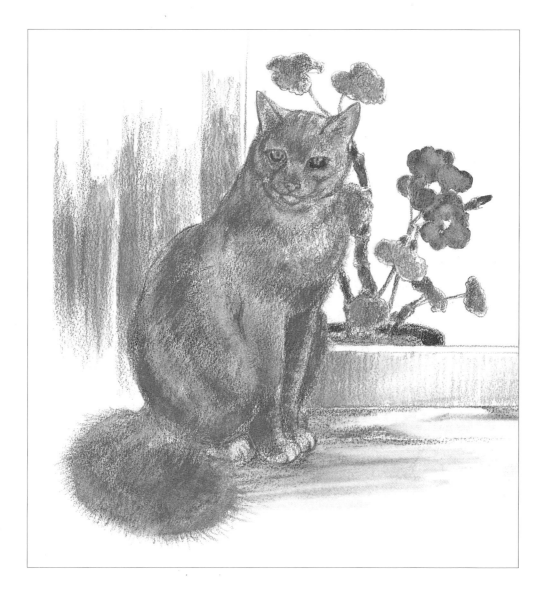

SEARCH PRESS

First published in Great Britain 2005

Search Press Limited
Wellwood, North Farm Road,
Tunbridge Wells, Kent TN2 3DR

ISBN 1 903975 56 5

The Publishers and author can accept no responsibility for
any consequences arising from the information, advice or
instructions given in this publication.

The Publishers and author would like to thank Winsor &
Newton for supplying many of the materials used in this
book.

Suppliers
If you have difficulty in obtaining any of the materials and
equipment mentioned in this book, then please visit the
Search Press website for details of suppliers:
www.searchpress.com

Alternatively, you can write to the Publishers at the address
above, for a current list of stockists, including firms that
operate a mail-order service, or you can write to Winsor &
Newton requesting a list of distributers.

Winsor & Newton, UK Marketing
Whitefriars Avenue, Harrow,
Middlesex, HA3 5RH

Publishers' note

All the step-by-step photographs in this book feature the
author, Sally Michel, demonstrating how to draw pets.
No models have been used.

There is reference to sable hair and other animal hair brushes
in this book. It is the Publishers' custom to recommend
synthetic materials as substitutes for animal products
wherever possible. There is now a large number of brushes
available made from artificial fibres and they are satisfactory
substitutes for those made from natural fibres.

**To
Alexandra and
Grace**

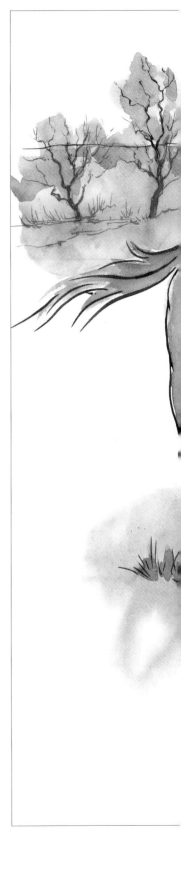

Page 1

*The drawing has been done
in pencil and watercolour
pencil – 8B for the cat,
coloured pencil for the
curtains, the window frame
and the pot plant. A small
amount of water has been
added to loosen the colour of
the curtain and the plant.*

Right

*This is a brush drawing. A
simple line drawing has been
done with a fine brush, and
a pale wash used to re-define
the colour of the horse, and
the nose, mane and tail. The
grass and distant trees
provide a contrast to the
horse's brown tones and give
balance to the picture.*

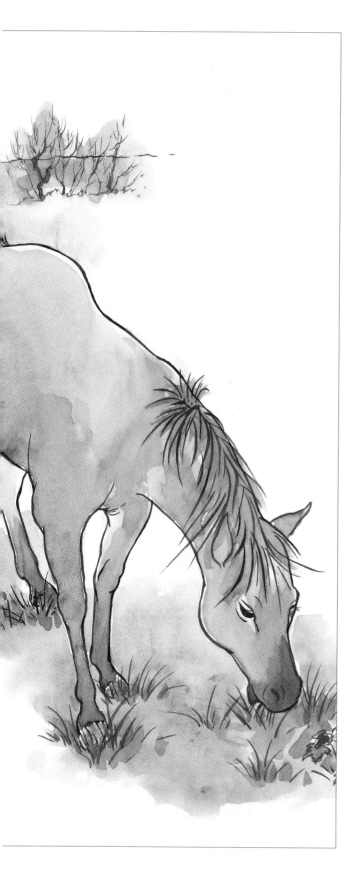

Contents

Introduction

Drawing involves exploring the form of individual objects, and how different forms relate to each other in three dimensions. As you draw you are gathering information, and when you have enough information you can use it to make a picture. Each time you draw the same thing you add to your knowledge of it.

So, how do you start? Look first, without drawing, then when you have sorted out in your mind what you are seeing, put it down on paper. That's all there is to it, really. When you've been drawing for a while you will find that you are seeing more and more, and that it gets easier to analyse what you see, and easier to put it down on paper.

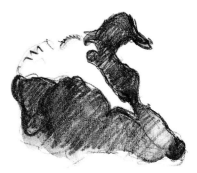

A study of the head of a sleeping dog done in water-soluble pencil – a little water was used to loosen the tone.

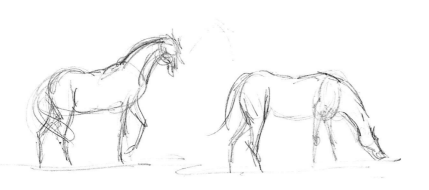

The main drawing was done using a soft black pencil. The colour was provided by watercolour pencils – reddish-brown and chrome yellow on the cat and olive green and cobalt blue on the background. Water was added once the drawing was completed.

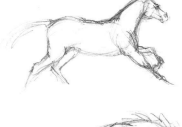

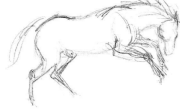

The drawings of the horses were done from life in B pencil.

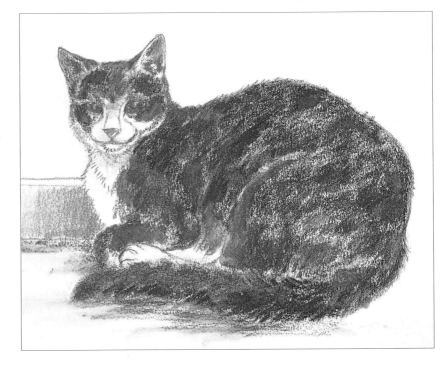

You can use almost anything to draw with – pencil, charcoal, crayon, chalk, pen and ink; brush drawings with ink or paint. Each has its own characteristic range of marks, depending on the paper you use to draw on – smooth card, textured pastel paper, rough rag paper, all add their own individual quality. If you use colour, remember that form, not colour, is the primary subject.

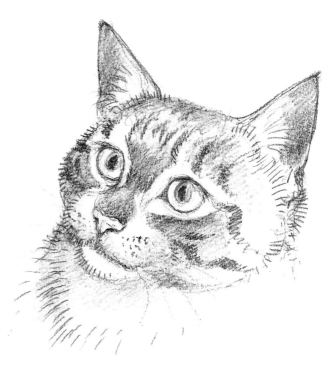

This drawing was done in water-soluble graphite pencil. The bulk of the drawing was a straightforward pencil drawing, with water only added for extra tone afterwards.

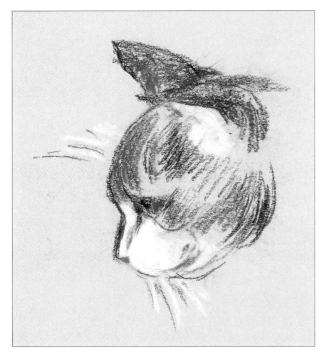

The main drawing was done in black using a hard pastel crayon. Colour was added in reddish-brown, white, and a touch of pink and yellow pastel pencil.

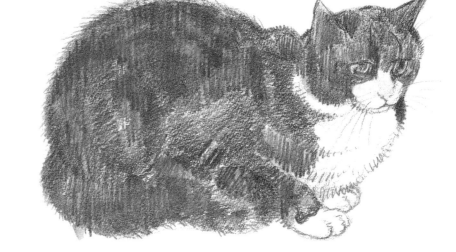

A study of my cat, Lucy. I did a straightforward drawing in watercolour pencil, defining the markings of the cat, and added colour afterwards with watercolour crayons. I added a little water at the end to blur the markings.

5

Materials

One of the most important considerations when choosing the materials to work with is ease of use. You must be able to draw quickly so that you can transform your thoughts into drawings without interference or delay. You need something to draw with (pencil, chalk, etc.), a surface to draw on (paper or card) and something to rest your drawing on while you work – a drawing board or a sketchbook with a rigid cover is ideal.

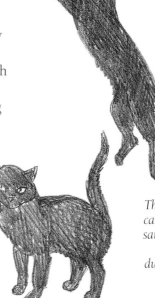

Water-soluble pencils and watercolour crayons are excellent recent additions to the draughtsman's toolkit. They can be used as conventional pencils and crayons, and then a wash of water applied to release a wash of tone or colour. You can devise other ways of using them too – drawing on wet paper, scraping tiny spots of colour on to a wet ground, etc. though these perhaps stray a little from what can strictly be called 'drawing'.

The silhouettes of the two cats demonstrate how the same cat can appear long and slim or compact during different phases of the movement.

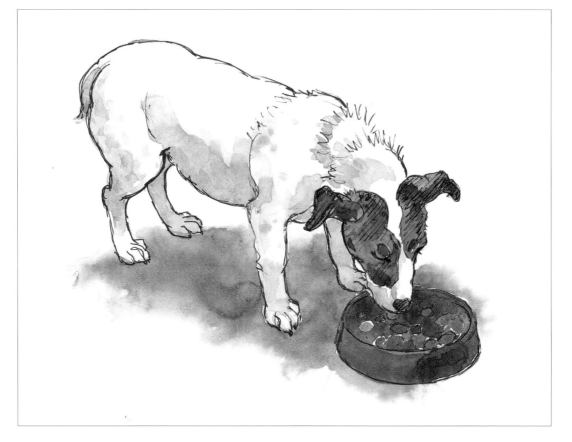

Dry drawing

Lead pencil (or more properly **graphite**) is probably the most widely used for studies from life. All grades from 6H to 8B have their uses; a hard pencil will define small details clearly, a softer one will be a sympathetic tool for quickly drawing an impression of a moving subject. Try different grades and use the ones you are most comfortable with.

Pastel crayon – hard pastel in the form of a crayon – sensitive and responsive; available in several different colours – sepia, grey, sanguine, several shades of brownish reds, white – all earth colours, so absolutely permanent.

Wax crayon – rich glossy black – needs a rough paper. Very good on rough watercolour paper.

Charcoal – just as black as wax crayon and far more easily smudged – can be smeared with a finger if needed.

Graphite stick – the same material as the inner core of a pencil but a great deal thicker; usually soft.

Chalk – lovely for crisp white drawings on a tinted paper.

Pastels – pigment sticks, either chalk or oil based – available in soft, medium or hard form. Soft pastels are usually thicker than hard pastels. A full range of colours is available.

Pastel pencil – hard pastel in the form of a pencil – use in preference to pastels where greater precision is needed, or for adding detail to a pastel drawing.

Water-soluble graphite – looks like a lead pencil, but has a soft graphite core which is soluble in water – good for adding tone and for blending.

Coloured pencils – these can supply full colour, if needed, to a drawing. Watercolour pencils have the capacity to release colour when water is added.

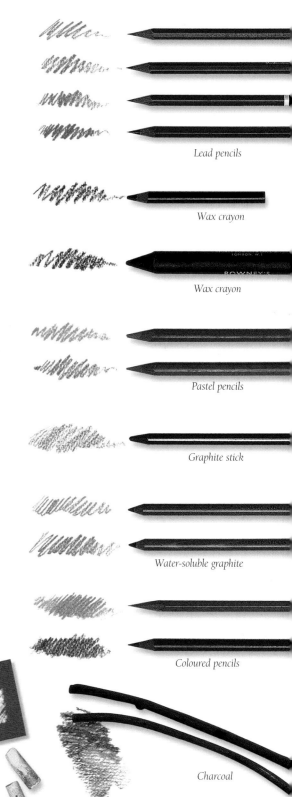

Lead pencils

Wax crayon

Wax crayon

Pastel pencils

Graphite stick

Water-soluble graphite

Coloured pencils

Soft pastels

Pastel crayons

Chalk

Charcoal

7

Pen drawing

Any kind of pen – dip pens with steel nibs, fountain pens, cartridge pens, pens with a continuous flow of ink, black, sepia or sanguine pens – can be used with or without a wash of watercolour added with a brush.

I have tried bamboo pens and have cut quill pens from the large wing feathers of geese – they all have their own individual characteristics. It's good to experiment with different equipment.

Ballpoint pens with their characteristic smooth, swift slipperiness can be very pleasant to draw with, but the drawings will be extremely fugitive and will completely disappear if exposed to daylight, so they must be kept in the dark and also photocopies made. The copies won't look like the originals but a good drawing is worth keeping even in an imperfect form.

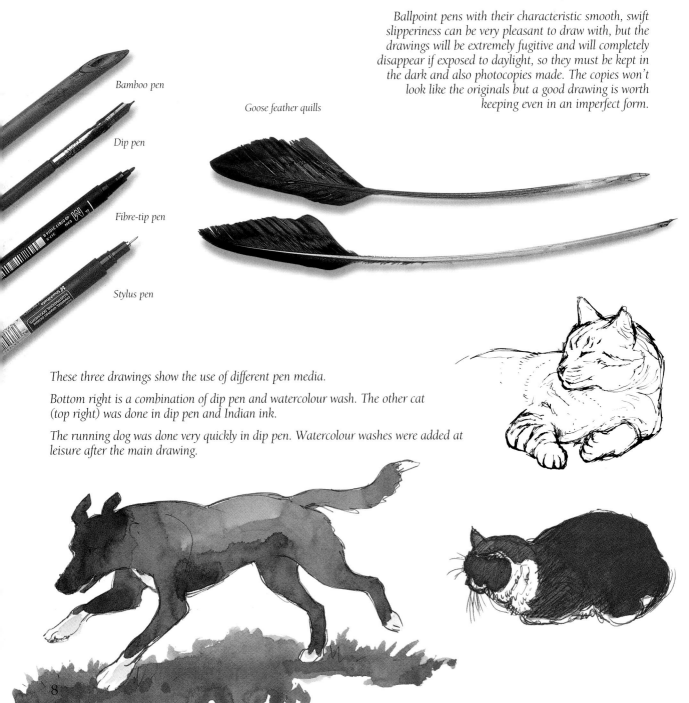

Bamboo pen

Dip pen

Fibre-tip pen

Stylus pen

Goose feather quills

These three drawings show the use of different pen media.

Bottom right is a combination of dip pen and watercolour wash. The other cat (top right) was done in dip pen and Indian ink.

The running dog was done very quickly in dip pen. Watercolour washes were added at leisure after the main drawing.

8

Brush drawing

Brush drawings vary according to the type of brush; a long-haired pointed brush, a club-ended one or a Chinese type of calligraphic brush will each give its own character to a drawing. Try something you like and use what you find most expressive and responsive.

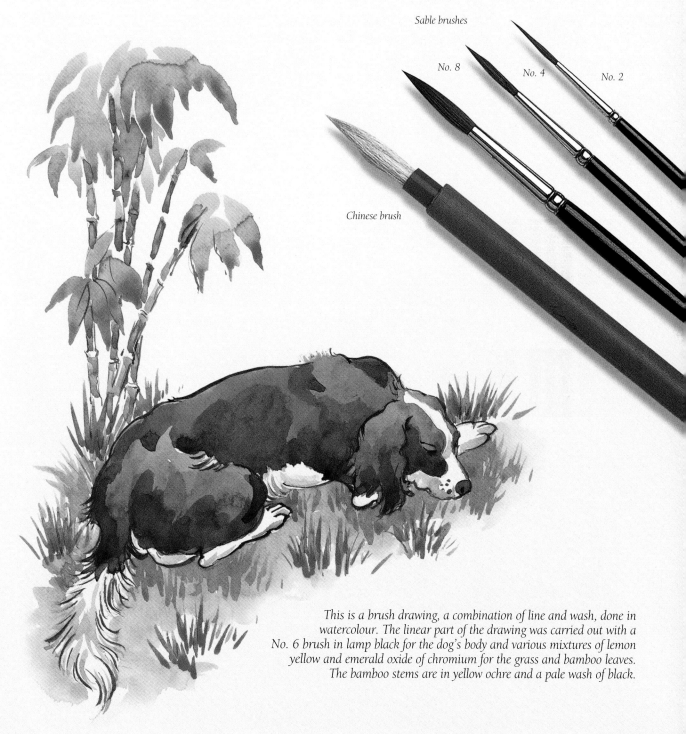

Sable brushes

No. 8

No. 4

No. 2

Chinese brush

This is a brush drawing, a combination of line and wash, done in watercolour. The linear part of the drawing was carried out with a No. 6 brush in lamp black for the dog's body and various mixtures of lemon yellow and emerald oxide of chromium for the grass and bamboo leaves. The bamboo stems are in yellow ochre and a pale wash of black.

Papers

Cartridge paper, bank paper and copier paper; white or tinted, smooth or textured – all are good for pencil. Hot-pressed watercolour paper, Bristol board and copier card are all excellent for formal pen drawings. Textured papers are good for crayon or chalk; a roughish watercolour paper for wax crayon. Try out different combinations of papers and tools for various effects.

A drawing done from life in pastel pencil on mid-grey sugar paper.

A study on black paper in grey and white pastel.

A pastel paper with (from left to right): black and reddish-brown hard pastel crayon, a water-soluble graphite pencil, an 8B pencil (top) and wax crayon (bottom).

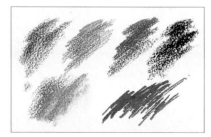

A rough watercolour paper with (clockwise from top left): a soft 8B pencil, an HB pencil, a hard pastel crayon, a wax crayon, a brush pen and a water-soluble pencil.

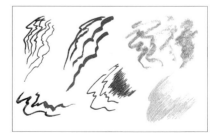

A smooth board showing the marks made by (clockwise from top left): a dip pen, brush pen, charcoal, an HB pencil, Indian ink pen and a goose feather pen.

Bits and pieces

Drawing boards

When drawing from life, I like to use a small, light drawing board – one made of plywood with rounded corners is ideal for this purpose. A hard-backed sketchbook can save you the extra burden of a board. For work in a studio, a large, standard drawing board is suitable.

Sketchbooks

I use sketchbooks when drawing from life. I find A4 is convenient, although I occasionally use A3. When completed, I file the drawings separately for future reference.

Erasers

Putty rubbers are useful when using pastel; otherwise plastic erasers can be excellent.

Sharpeners

When using pencil, a piece of fine sandpaper or an emery board will keep your point sharp. If you prefer, a craft knife can be used, or a pencil sharpener. These are available in different sizes to suit various thicknesses of pencil and crayon.

Pastel brush

While working in chalk or pastel, you can create a smooth surface without a break by using a pastel brush. This is very handy, for example when doing fine, fluffy fur.

Fixative

This is useful to avoid smudging if the drawings are in pastel.

Masking fluid

A liquid applied to areas of a painting that you want to protect from subsequent colour washes. When dry, it can be gently peeled or rubbed off.

(Clockwise from top): masking fluid, fixative, sandpaper, emery board, eraser, sketchbook, putty rubber, sharpener, pastel brush, craft knife.

11

How to start

When drawing pets, it's simplest to start with a sleeping animal for the obvious reason – you have time to do your looking for longer. Don't be too ambitious in the early stages of your drawing – go for the main forms first and leave the details for later. Think of your pencil lines as marks enclosing a solid form rather than a map of the edges. If your subject moves, start another drawing. Even tiny rough sketches convey some information and are worth keeping.

These drawings of my Jack Russell terrier are done with an HB or B pencil – my favourite basic medium for making studies from life – responsive enough for recording swift movement, but hard enough to define small detailed forms clearly.

There's no need for a lot of shading. It is often over-used by the beginner; a highly shaded drawing with exaggerated contrast of light and shadow doesn't necessarily show superior skill. I prefer to add shading to a drawing, if at all, to indicate differences of tone and patterns of marking.

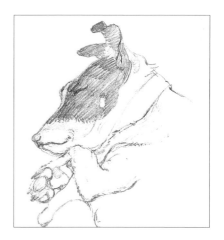

These drawings show the result of a typical session of drawing a sleeping pet – some sketches of more or less the whole animal, depending on how long it stays in a particular place or position, with a number of drawings of details of ears, feet, etc. and positions held for a few moments with no time to finish.

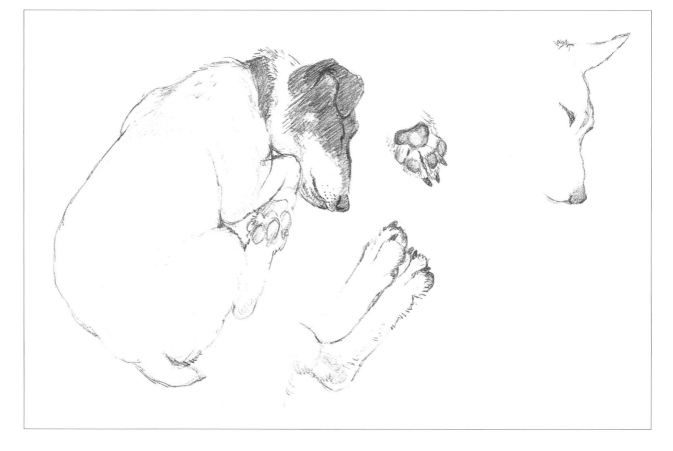

Perspective

Don't be afraid of terms like 'perspective'. All perspective means is how things look to you from where you are looking at them. Move your head and the perspective changes.

There are many rules that can be used to construct a picture from different pieces of information when the object portrayed is not in front of you. Knowing these rules can prompt you to look at the world in ways you might otherwise have missed. More specifically, they can help you understand the principles of exactly how distance affects the apparent sizes of what you see, the behaviour of reflections and the different factors affecting shadows thrown by the sun or artificial light sources.

When you draw from life the information is all there. Keep to the same viewpoint and, if you draw what you see, the perspective will be correct. The difficulty lies in drawing *only* what you see. Resist the temptation to put in details that you think you know are there but can't quite see. Take a closer look and check it later, but for now draw only what you *can* see.

A vertical board held at right angles to your line of vision helps you to draw the proportions correctly. If your drawing surface is too nearly horizontal, its own perspective will interfere.

Remember that the difference between the actual and the apparent size of an object is much bigger than you might imagine it to be.

The cat's head appears larger in the picture below than in the one above because it is closer to the artist.

13

Composition

Drawings from life of your cat or dog are complete in themselves; full of life and character, they prompt recall of far more than the sketch actually contains, even when the animal is not present.

If you wish to do a more elaborate picture of your pet, your life studies are the essential starting point. You can add a decorative setting by choosing a pleasing background that might not have been available at the time. For example, perhaps you would like to present your cat in an elegant and aesthetically pleasing setting and you have a particularly successful life-like drawing of him, but at the time he was sitting on the breakfast table, on a newspaper with a background of milk bottles and used cereal bowls. He might have been nicely posed in front of a bowl of flowers but beside some large, awkwardly shaped article that would take up far too much room in the foreground.

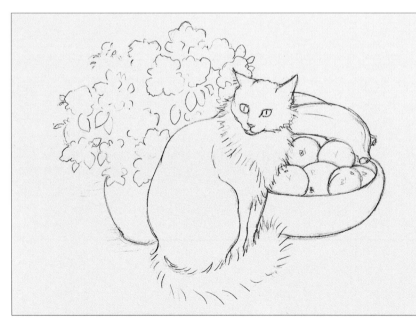

Decide what elements you want to include in your picture and compose it. Try the different elements in various positions – make a rough sketch of each one on a scrap of paper and move them about in relation to one another to find the most pleasing combination – no need for much more than an outline at this stage. Try to get a good balance between the separate elements of your composition.

Justin the Cat

You will need

Rough watercolour paper

Coloured pencils – medium grey, olive green, orange, yellow ochre, dark red, purple, grass green, yellow-green, bright yellow, light grey, dark grey, medium brown, soft black, medium blue, lilac

Sharpener

1. Use the medium grey and a light touch to draw the basic shapes of the cat.

2. Use the olive green to draw the basic outlines of the pot plant.

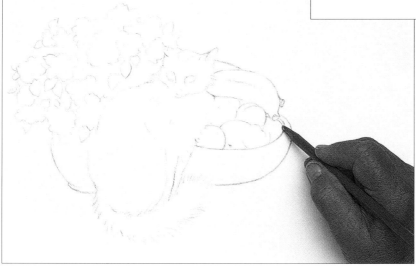

3. Use orange, yellow ochre, dark red and purple pencils to draw the bowl and fruit.

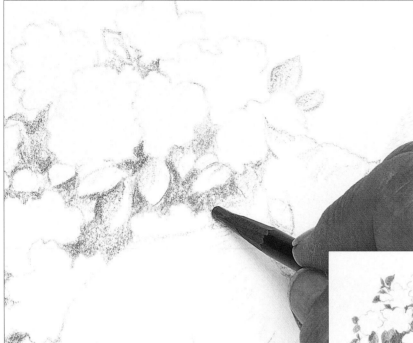

4. Start to work up the leaves with the grass green, then, applying colour on colour, use other greens to develop the dark areas of shadow between the flowers.

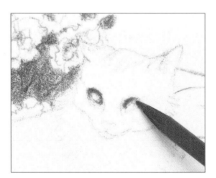

5. Work up the bright highlights on the leaves with the yellow-green, then intensify the deep shadows with purple.

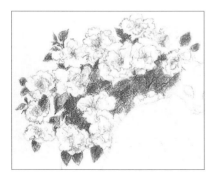

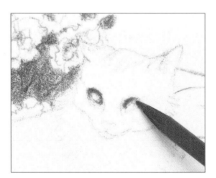

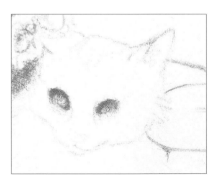

6. Now work up the shape of the white flowers with touches of yellow-green and olive green; develop shadow areas on the petals and knock back some of the brighter greens on the leaves.

7. Colour in the cat's eyes with bright yellow, adjusting the applied pressure to create a roundness to the eyeball.

8. Emphasise the curve of the eye with the light grey pencil, then use the dark grey to develop the pupil.

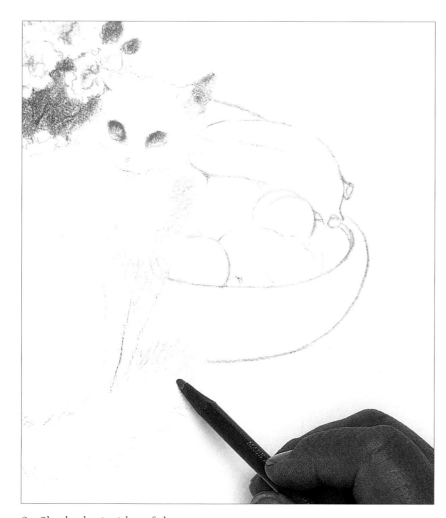

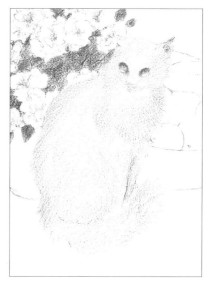

10. Develop the cat's fur with the light grey pencil. Work from the head downwards, adjusting the applied pressure and depth of colour to create form.

9. Shade the insides of the ears with medium brown, varying the applied pressure to create form. Use the same colour to define the underside of the eyes and the nose and mouth. Black cats often have a brown tinge to their fur, so, using the same colour, apply a light shading to parts of the chest and tail.

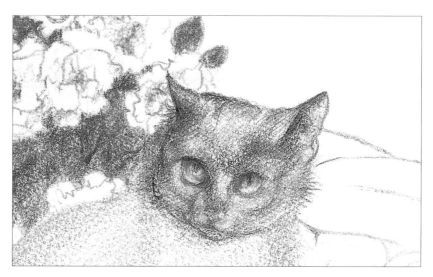

11. Use soft black to work up the darkest tones on the cat's head, adding detail around the eyes and ears, then add touches of purple.

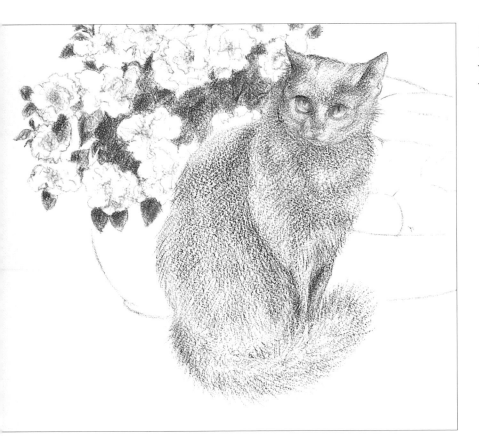

12. When you are happy with the tonal structure of the head, work up the darks on the body with the soft black.

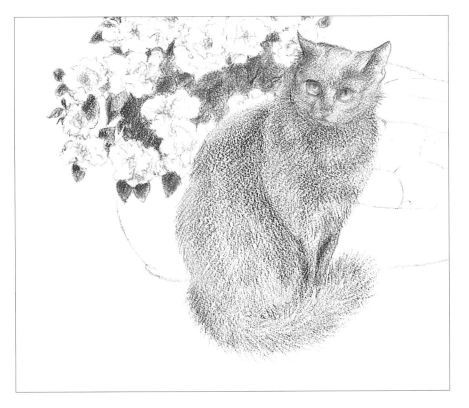

13. Accentuate the lighter parts of the body fur and the head with the medium blue.

14. Enrich the dark parts of the body and head with purple.

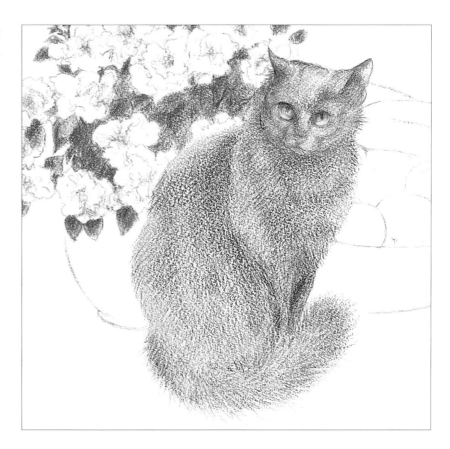

15. Use the bright yellow to block in the bananas, the yellow plums and a base colour on the apples. Use the yellow ochre pencil to block in a base coat for the wooden bowl.

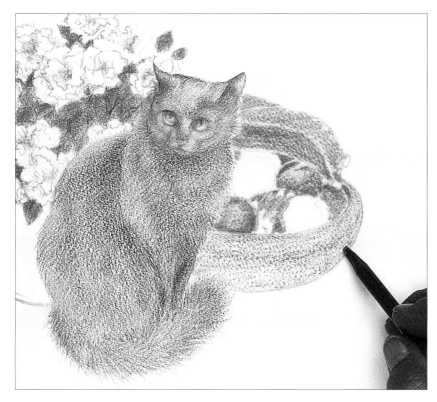

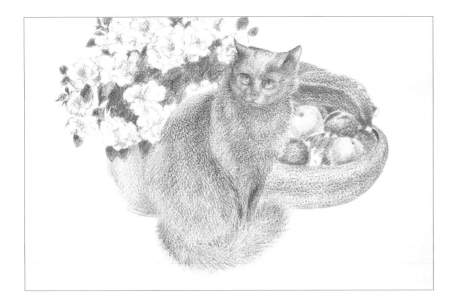

16. Use lilac to create the bloom on the purple plums and to block in the shape of the flower pot. These marks help link all the component parts of this composition. Develop the shapes of the bananas with touches of yellow-green. Use the purple pencil to add darks to the purple plums and to develop shadows on the bananas, the bowl and the plant pot.

17. Use the orange, shaded lightly with dark red, to work up the shape of the yellow plums. Work up and apply orange base colour for the apples, then overlay this with a variety of dark red tones. Use the purple to redefine deep shadows and the yellow ochre to warm up the wooden bowl.

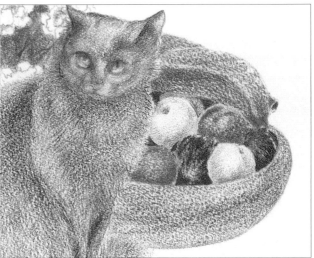

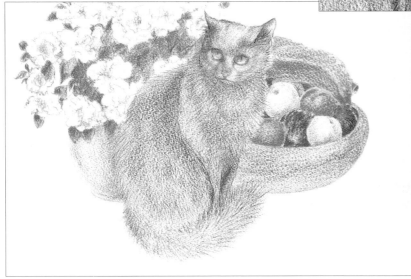

18. Sharpen the soft black pencil to a fine point, then add details to the cat: sharpen the shapes of its eyes; add in some hairs in the ears; flick in the whiskers; and add some hairs on its back, down the chest and round the tail. Add fine shadow lines around the fruit and bowl.

The finished drawing. Olive green has been added to the foreground to complete the drawing.

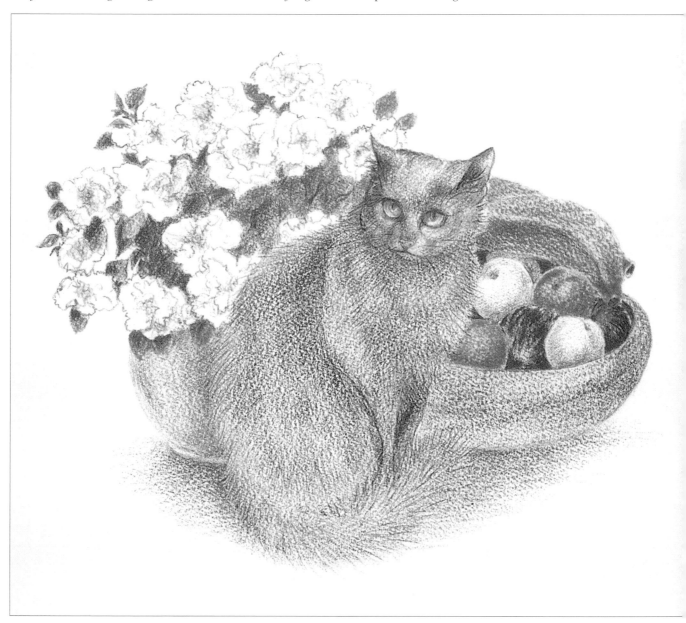

Anatomy

Try to get some idea of the anatomical structure of the animal you are drawing. First there is the skeleton, the bony frame composed of inflexible pieces that move against each other, but do not themselves change shape. They are moved by the muscles, which bunch up or stretch out so that they change the external shape of the animal.

Eyelids cover most of the eye, and movement of the eyes seems to change their shape; the ears can turn and move with movements of the skin.

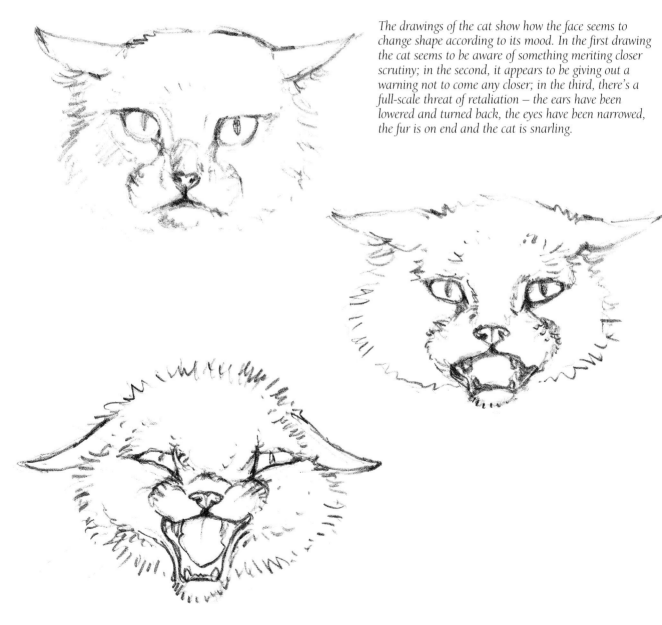

The drawings of the cat show how the face seems to change shape according to its mood. In the first drawing the cat seems to be aware of something meriting closer scrutiny; in the second, it appears to be giving out a warning not to come any closer; in the third, there's a full-scale threat of retaliation – the ears have been lowered and turned back, the eyes have been narrowed, the fur is on end and the cat is snarling.

In the picture below, see how the dog's skull, the hard inflexible box that protects the delicate brain, has a hinged lower jaw that allows the mouth to open very wide. The eye sockets and ear holes show that these organs are fixed in place.

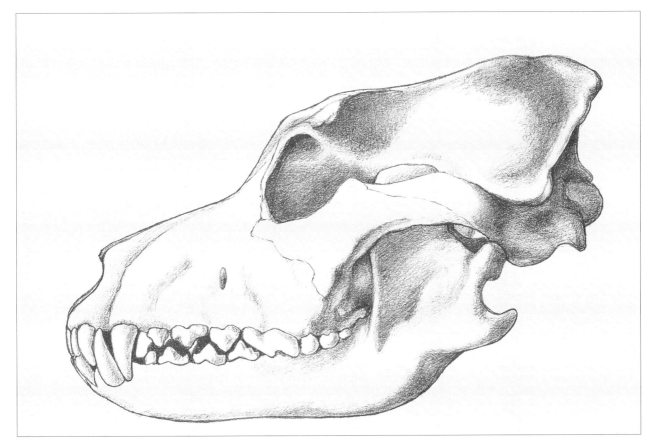

This drawing of the dog's skull is very different from the loosely drawn sketches from life of an active animal. I was able to take advantage of its immobility to explore at leisure not just its overall shape but also the small forms within the main shape that prevent it from being completely smooth and featureless. I have used a small amount of shading to emphasise these minor unevennesses. It also demonstrates another approach to drawing.

The relationship between all animals is shown by the drawings on these pages. They show how the skeletons of human, dog and horse fit in their skins – they are similar in structure, though the individual bones are different in size, shape and number; for example, the horse has lost some toes and there is no external tail in the human.

All the main bones are recognisable in each animal. Each of them has a skull, a spinal column, a rib cage, a pelvic girdle, shoulder blades, a long bone in each upper limb and two smaller bones in each lower limb. The feet, though greatly evolved, all have vestiges of the same bone structure.

The muscles are joined at each end to a bone (directly or indirectly). They move the limbs by 'bunching up' so that the muscle becomes thicker and shorter. These changes naturally affect the shape of the animal; any cat owner will be familiar with the way their pet can change from being compact and rounded into an animal of a completely different form – long and stretched.

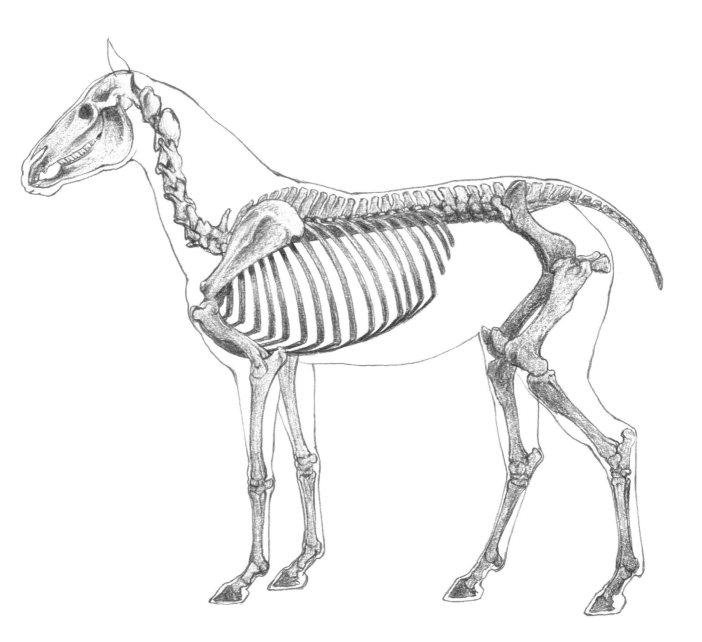

Each animal's way of life has led to changes in the skeleton and other parts of its anatomy through the millennia, and this can be seen clearly in the changes to the feet. The dog walks on the equivalent of its fingers and palm, and the horse on the one remaining toe on each foot, or more correctly on the nail which has evolved into a hoof. The dog's nails have become claws. In both species the hind foot is greatly elongated and the heel is halfway up the leg. These changes reflect both animals' abilities to run for great distances without tiring.

Drawing a moving animal

This is where it gets difficult. You need not worry if, after a period of concentrated hard work, you have pages and pages of small bits of drawings. If you are able to watch, for instance, a family of kittens playing or a dog digging, you may well find that the same pose occurs several times. Try to observe a different part of the animal each time, and after a while you might have enough drawings to put them together and make a picture of the whole. A single line showing the shape of the back with no other detail can help you to recall a whole pose. Photographs and video recordings are invaluable to help you see the whole scene again, even in slow motion, so that you can analyse it thoroughly. When you are familiar with how your cat moves it becomes easier to recall it as you draw.

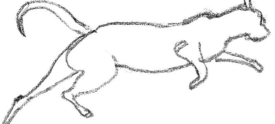

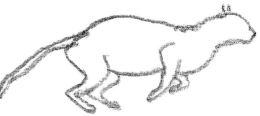

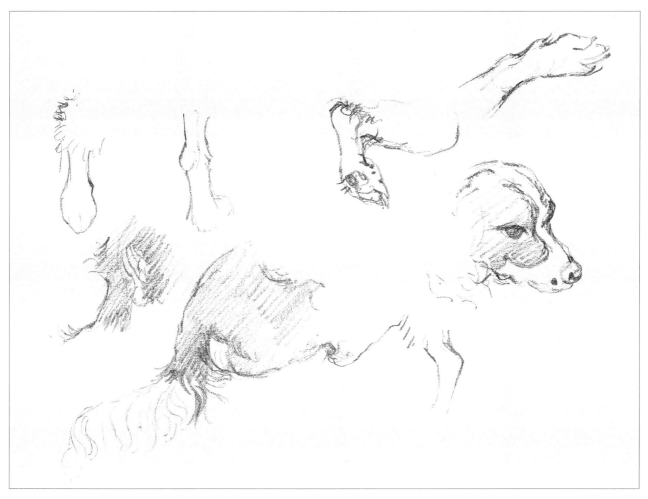

Drawings of movement are naturally much freer and lighter in handling than a settled study done at leisure, which in itself contributes to the liveliness of the drawing and helps to convey the swiftness of movement.

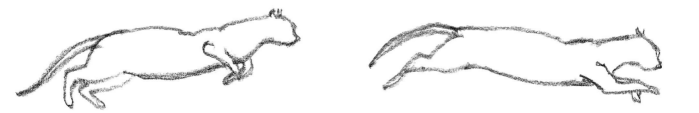

Don't be too ambitious at the beginning. You won't have time to study the finer points of detail. At first, see if you can produce just a line that will recall the posture of a leaping or running animal. It can be quite exhilarating to look at a sheet of such lines and see how vividly they remind you of how your pet looked at the time. Seize on the essential characteristics of the movement and don't worry about the extra details you don't have time to observe, such as legs, ears, feet, etc. If the same action is repeated you will be able to add these later.

As with everything else, practice makes, if not perfect, at least much better than your earlier efforts. If the animal is your own pet you have an enormous advantage, as each drawing session builds on the previous ones, giving you the luxury of a second (or third or fourth) bite at the cherry.

A very swift drawing, done in hard pastel crayon from repeated viewings of a video recording.

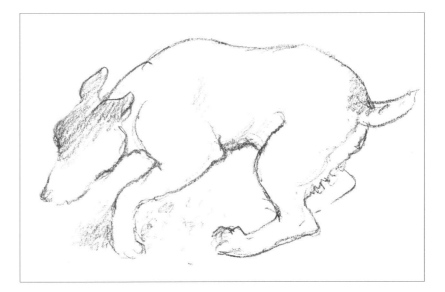

Another way is to sit in the park and draw the ducks, which will obligingly perform the same movements over and over again. Never mind what the resulting drawing looks like – just enjoy doing it.

If you are aiming to produce a finished picture, you can use what you have to hand to get what extra information you need. You can check the shapes of ears and feet, hair patterns and so on when the animal is sleeping after its exhausting activity (exhausting for you too – concentrated drawing can be surprisingly tiring). You can also stop the video to see what passed you by too quickly, and you can learn a lot from carefully studying your photos.

These horses were swiftly drawn from television using a B pencil.

The movement of the dog digging, although constantly changing, permitted me to draw its general shape over several minutes of the same repeated action.

The Running Dogs

What a blessing is the video recorder. You can, of course, stop the action and draw the animal in mid leap, but you'll be a better draughtsman if you can play the recording over and over again at full or reduced speed, and draw it as it moves.

The dogs have been drawn from video recordings; they make it possible to study the movement in slow motion, several times if necessary. Once you thoroughly understand the motion, it is time to draw.

You will need
Red transfer paper
Sharp 3H pencil
Pastel paper
Hard pastels – white, black
Soft pastels – white, black
Pastel pencils – red-brown, flesh, white, olive green, grey-green

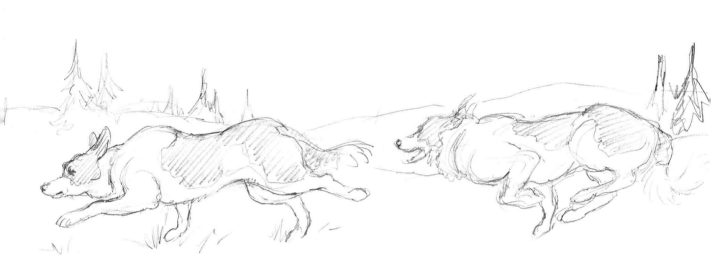

1. Using red transfer paper and the sharp 3H pencil, transfer the outlines of the two dogs on to the pastel paper. For this demonstration, I wanted more space between the two dogs, so I transferred the right-hand dog, then moved the tracing to the left before tracing the other one.

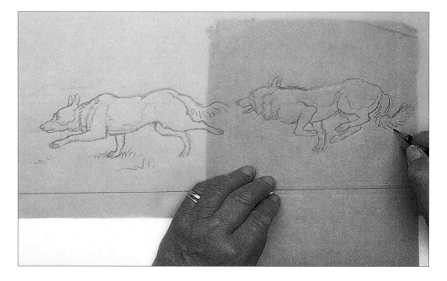

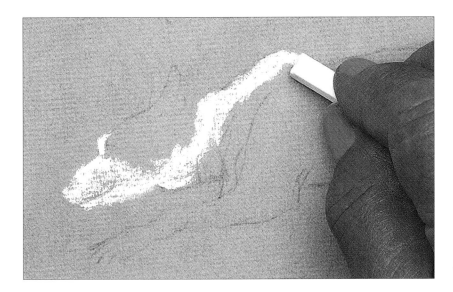

2. Using a clean, sharp edge of the hard white pastel, lay in the white parts of the dog's head.

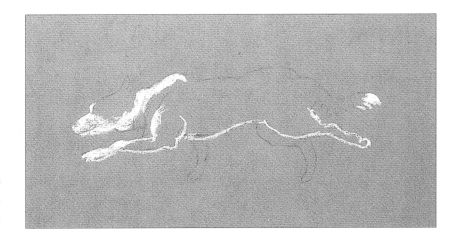

3. Draw in the outlines of the leading foreleg, the chest, trailing rear leg and the tail.

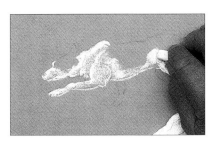

4. Change to a soft white pastel and use the side of it to block in the white areas, adjusting the pressure as necessary to create the form of the muscles.

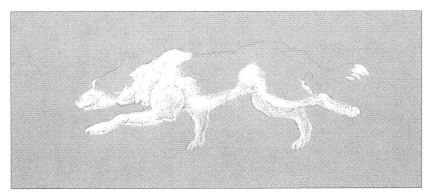

5. Use lighter touches of both white pastels to outline and block in the right front and rear legs to complete the white areas of the dog.

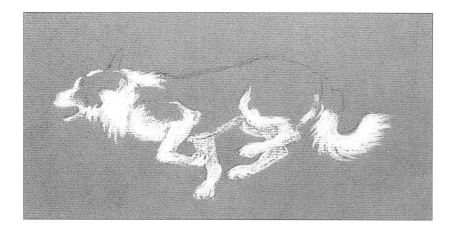

6. Use the hard and soft white pastels to work up the right-hand dog in a similar manner.

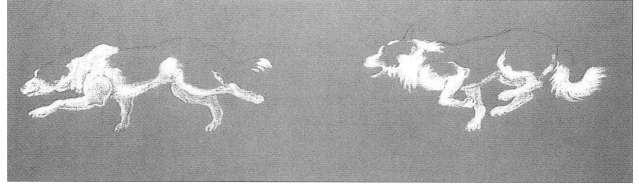

All white areas completed on both dogs.

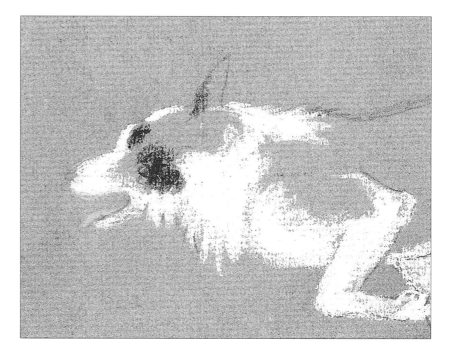

7. Use red-brown pastel pencil to add the brown tones on the face of the right-hand dog. Use the flesh pastel pencil to draw in the tongue.

8. Use a hard black pastel to draw the outlines of the black markings on the left-hand dog.

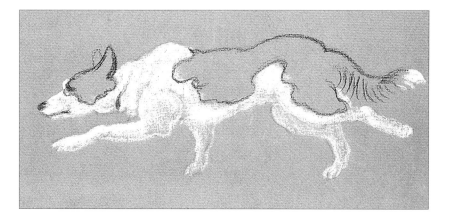

9. Use the soft black pastel to block in these areas; vary the tone to define the dog's shape.

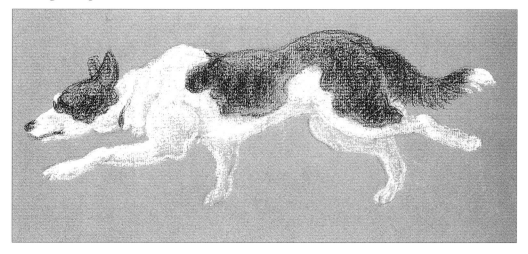

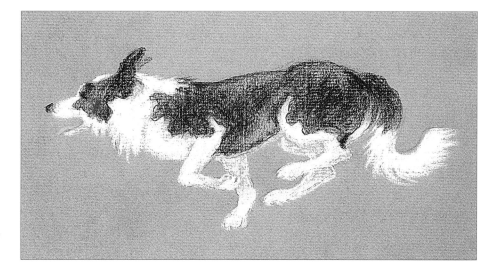

10. Work up the right-hand dog in a similar manner.

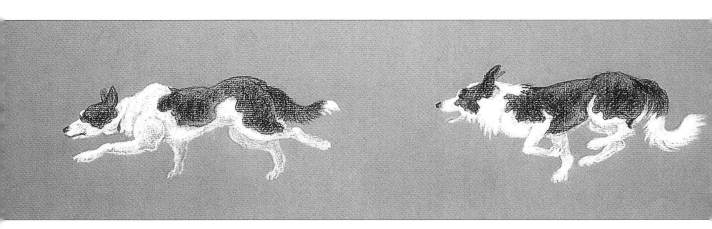

11. Working with a very light touch, use the white pastel pencil to draw in the background hills and trees.

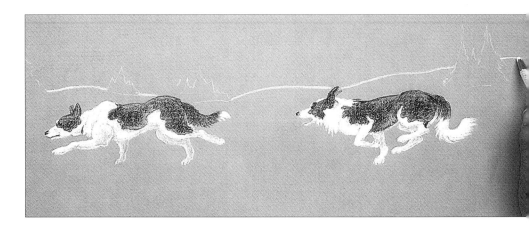

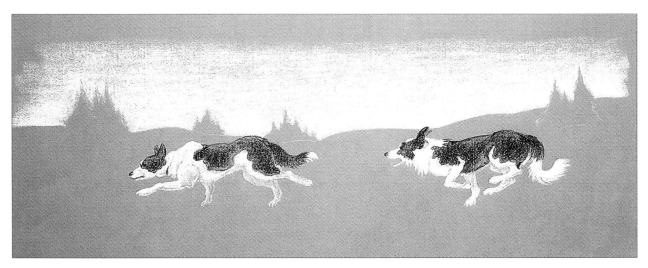

12. Use the side of the soft white pastel to block in the sky – cutting in round the shapes of the trees, and softening the tone as you work upwards from the hard edge of the background hills. You may find it easier to work the sky with the drawing upside down.

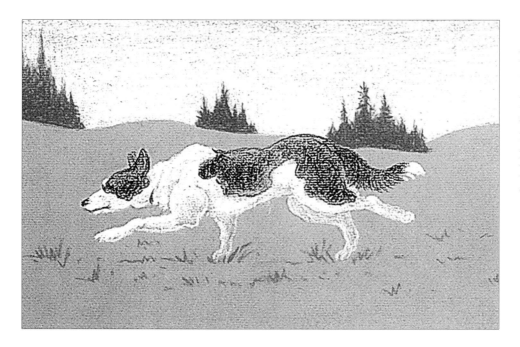

13. Use the olive green pastel pencil to rough in the trees. Use the grey-green pastel pencil to scribble in the indication of grasses in the foreground to help ground the feet of the dogs.

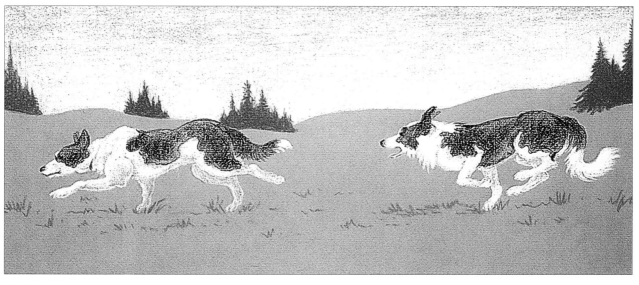

The finished drawing.

Drawing small animals

There are many small animals that live largely in cages, mostly rodents: hamsters, gerbils, rabbits, guinea pigs, rats, mice and chinchillas are some of them. Once a species becomes accepted as a pet, various colours are bred and different coats developed, so the choice of possible pets is enormous. Guinea pigs range from short-haired varieties to those with long and silky coats in all kinds of colours. The medley of colours, coat types and sizes of the tame rabbit is astonishing when you think that they are all bred from the original wild species.

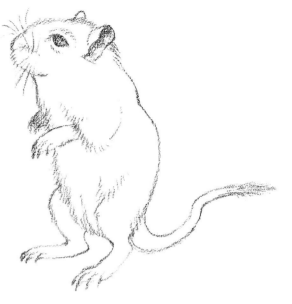

The gerbil was drawn with a 6B pencil on watercolour paper.

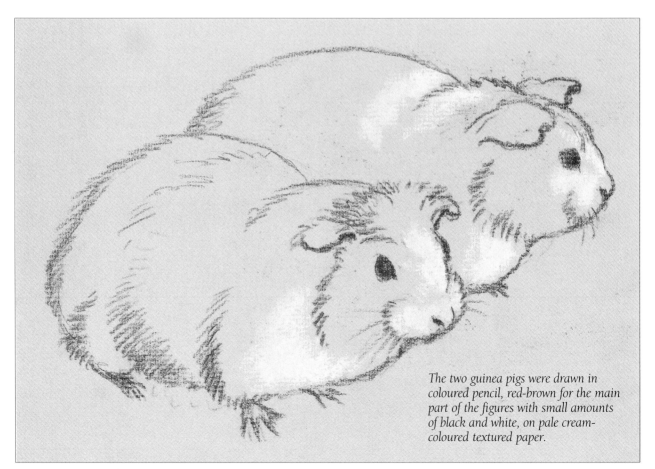

The two guinea pigs were drawn in coloured pencil, red-brown for the main part of the figures with small amounts of black and white, on pale cream-coloured textured paper.

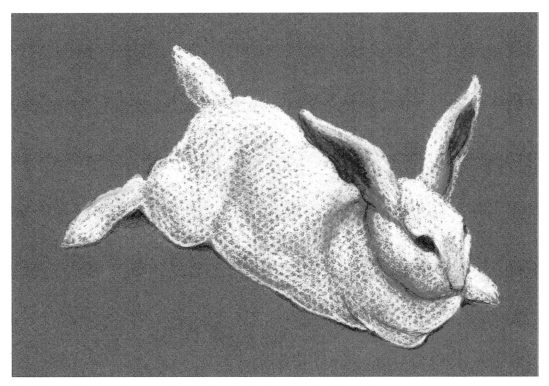

The albino rabbit was drawn in white, pale grey, dark grey and pink pastel on a pastel paper in smoky grey.

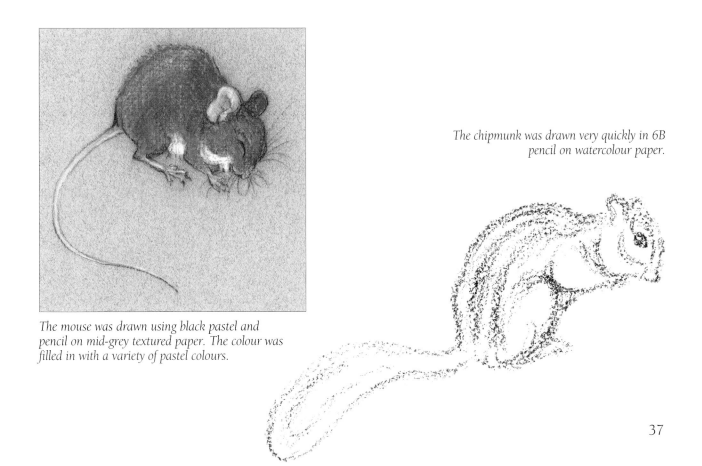

The chipmunk was drawn very quickly in 6B pencil on watercolour paper.

The mouse was drawn using black pastel and pencil on mid-grey textured paper. The colour was filled in with a variety of pastel colours.

Drawing animals in their natural settings

Good pictures can be made of other people's pets in a wider setting; cats on garden walls, dogs out walking with owners, ponies or donkeys in paddocks, etc. Try sitting on a park bench sketching the view and including the passers by, both human and animal. A few examples of this kind of drawing are shown on these two pages.

It doesn't matter if your drawing is loose in handling and reticent about details. It all adds to the movement and liveliness of the result.

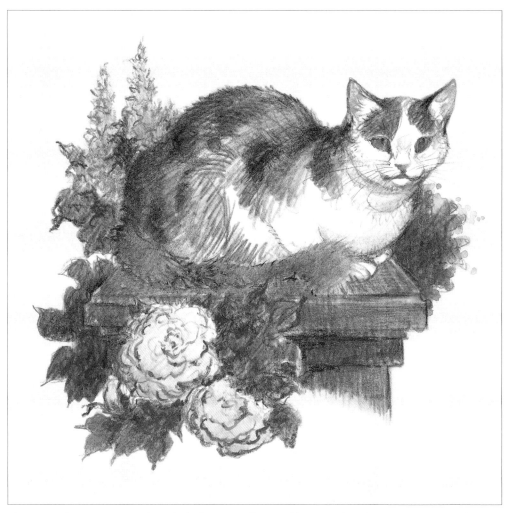

The cat on the gatepost posed nicely for long enough to enable me to draw her. Later on I added rather more in the way of floral background than was actually there to improve the composition and increase the decorative impact of the whole scene.

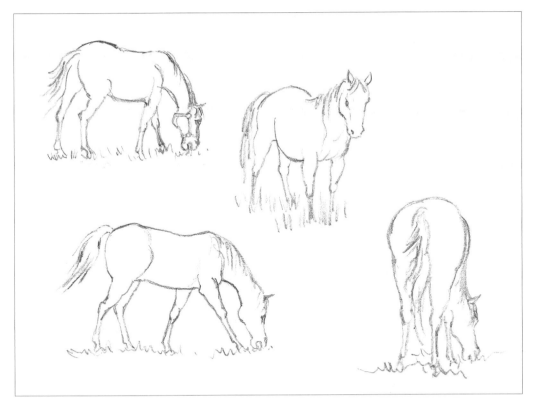

Horses and donkeys hoping for a titbit are often very quick to approach a human.
When none is forthcoming they will obligingly move off and carry on grazing. This is
useful as it gives you the chance to study details of the formation of their eyes,
nostrils, ears and so on.

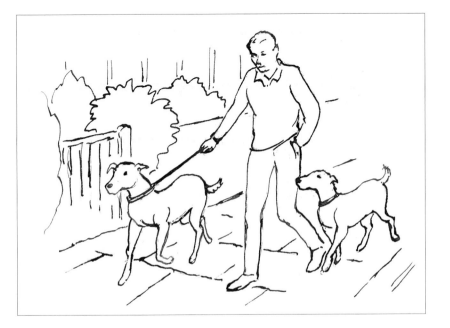

Dogs, of course, are more likely to be on
the move unless two owners stop for a
chat – a chance to get another
interesting composition.

The Horse

I selected the horses for this study from all my life drawings of the horses – close-ups of their heads, sketches of them grazing and walking, details of the ears, eyes, etc. To make a better picture, some drawings of their field and various features – clumps of trees, gate, fence and so on – were used to make a more pleasing setting than the actual one.

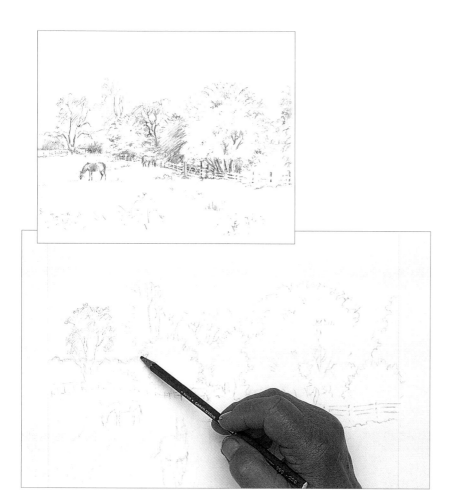

1. Compose the drawing on the watercolour paper. Use green to rough in the foliage of the tree at the left-hand side of the composition and to mark in the tops of the more distant trees.

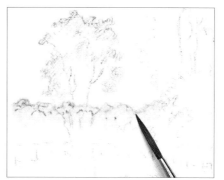

2. Use a No. 4 round brush and clean water to soften the edges of the foliage. Clean the brush, then pull down the colour of the drawn line of the more distant trees.

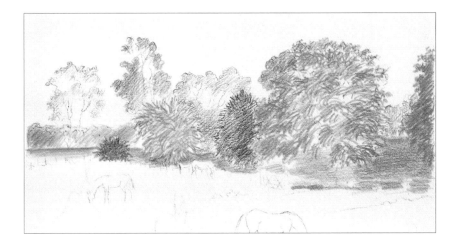

3. Gradually work across the composition, using the green and the dark brown pencils to lay in the base colours for the various elements of the background. Vary the tones to create form, and try to set light tones against darker ones.

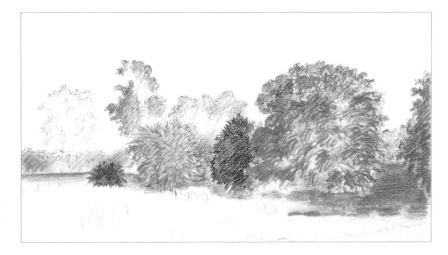

4. Use the No.4 round brush and clean water to soften the colours in the trees and fields. Leave to dry.

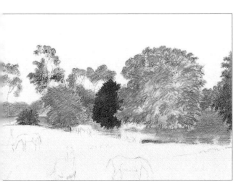

5. Now go back over the background, overlaying it with yellow, raw sienna and all the greens to create more depth. Introduce touches of lilac and purple to create shadowed areas.

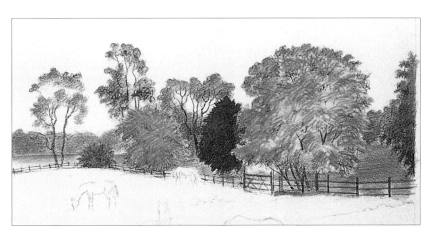

6. Use dark brown to indicate exposed tree trunks and branches. Use the same colour to draw in the fence, leaving a gap where the most distant horse will be. Use purple to darken the shadowed side of the trunks and dark blue to create shadows on the fence.

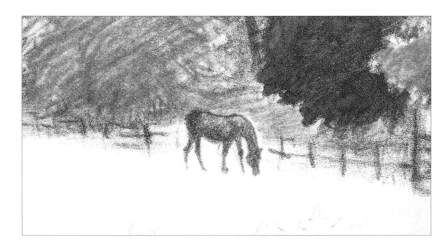

7. Use warm brown to block in the most distant horse grazing against the fence. I purposely chose this bright colour to counter the dark tones of the background. Even though this horse is quite small you still need to capture a natural pose.

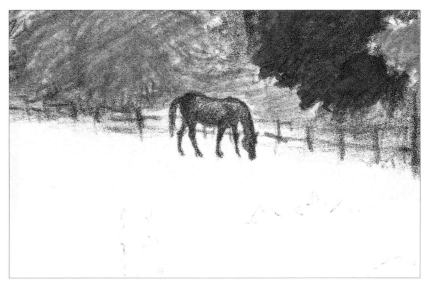

8. Sharpen the dark brown pencil to a fine point, complete the fence behind the horse then develop the detail of the horse, adding a tail, its feet, a mane and small shadows.

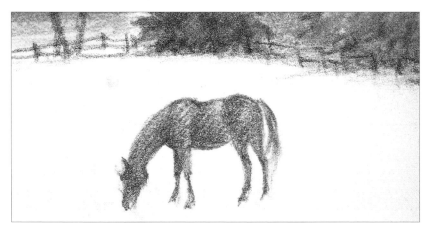

9. Use warm brown to block in the horse on the left-hand side. It is nearer to you than the first horse, so it needs slightly more detail. Use the mid brown to darken the front leg.

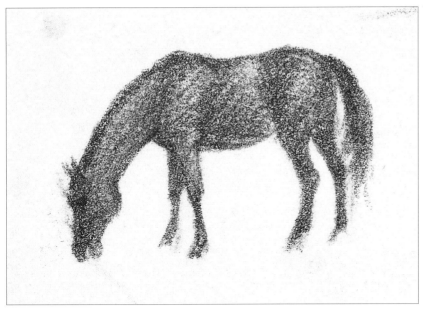

10. Use the medium and dark brown pencils to shade over the undercolour to develop form and to detail the eyes and ears.

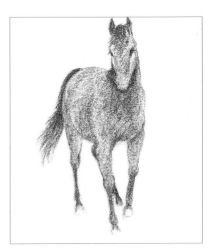

11. Use mid brown to draw the outline of the horse walking into the foreground.

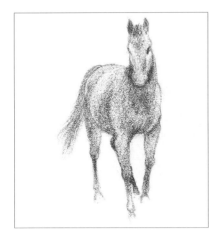

12. Use the same colour to block in the basic body parts, varying the tone to create form, and leaving the white of the paper as highlights.

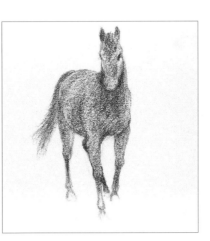

13. Use light brown to develop the colour on the horse's chest, back, rump and head.

14. Complete the detail on this horse using dark brown and black.

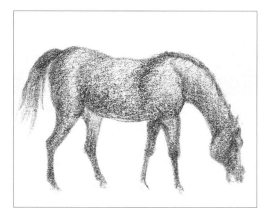

15. Use dark brown to work up the shape of the horse on the right-hand side.

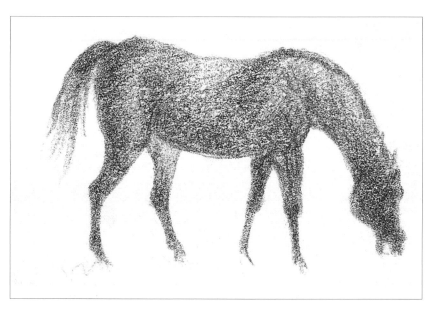

16. Develop this horse by blending the mid brown into the darker undercolour.

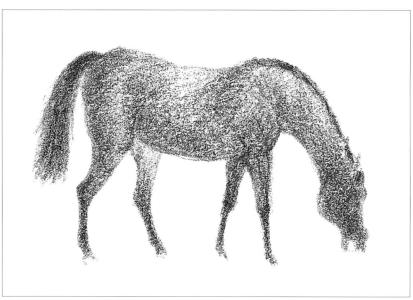

17. Finally, use the black pencil to add the fine detail.

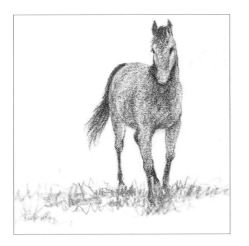

18. Use the greens to indicate patches of grass to ground each horse, and to indicate shadows from the background foliage.

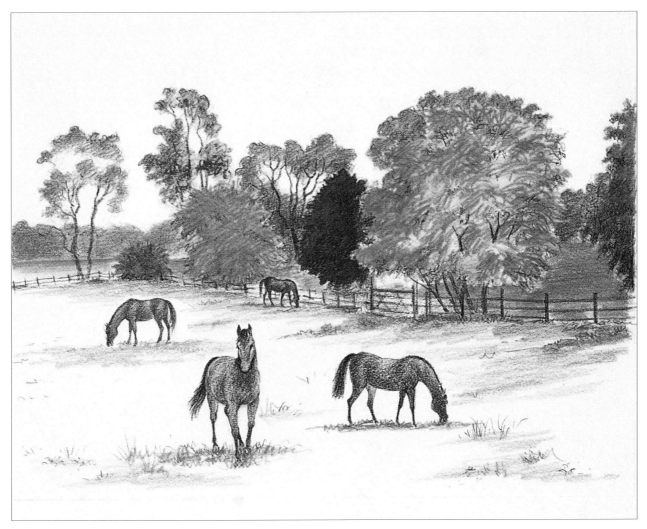

The finished drawing.

Dog portrait

This beautiful huge puppy is one of an uncommon breed – a Leonberger – popularly supposed to have been bred to resemble lions, but with more approachable personalities. Certainly, this young female (about 9 months old when I drew her) has a most agreeable temperament, a handsome mane and a blackish tip to her tail. I spent a couple of hours doing half a dozen sheets of drawings from life, observing her as she moved and walked around her garden. I also took a number of photographs.

For the portrait, I decided to use one of these photographs to base the picture on – not to copy it, but to use it as a reminder of what I had studied and drawn.

The first essential was to redraw all that part of the dog that was furthest from the camera. To have copied the photograph as it was would have led to a considerably distorted figure with an exaggeratedly large head and disproportionately small hindquarters and back paws. I used the photograph simply to establish the pose of the whole animal and to refer to for any details either I had no drawings of or where my memory needed re-enforcement.

Working in this way brings back to one's memory the whole process of doing the drawings from life.

Ideally, I would have returned for another sitting. That was not an option, but I had many drawings and many more photographs to serve as reminders.

The whole figure was drawn using a lightish grey watercolour pencil, then worked with different colours of the same – yellow ochres (pale and deeper), black and mid grey, pink and crimson for her tongue and reddish brown for her eyes. The main effect, though, is of a two-colour drawing in black and yellow ochre.

Index

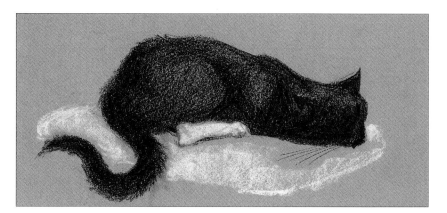